ROBERT YOUNG'S
DAILY INSPIRATION
VOLUME 1

YOUR GUIDE TO **HOPE**
IN TIMES OF HOPELESSNESS

PUBLISHED BY ROBERT**YOUNG**IAM.com
© 2019 BY ROBERT YOUNG
ISBN 978-0-578-56156-1

All rights reserved. No part of this publication may be reproduced, distributed, or transmitted in any form or by any means, including photocopying, recording, or other electronic or mechanical methods, without the prior written permission of the publisher, except in the case of brief quotations embodied in critical reviews and certain other noncommercial uses permitted by copyright law. For permission requests, write to the publisher, addressed "Attention: Permissions Coordinator," at www.ROBERT**YOUNG**IAM.com/contact.

Cover and Interior Design, Photography and Typography by Robert Young.

For information on bulk book orders, photography print purchases, or speaking engagement bookings for Robert Young's Inspirational Talk Series please contact us at www.ROBERT**YOUNG**IAM.com/contact

Dedicated to **Vinette Young** and **Llewelyn Brown**

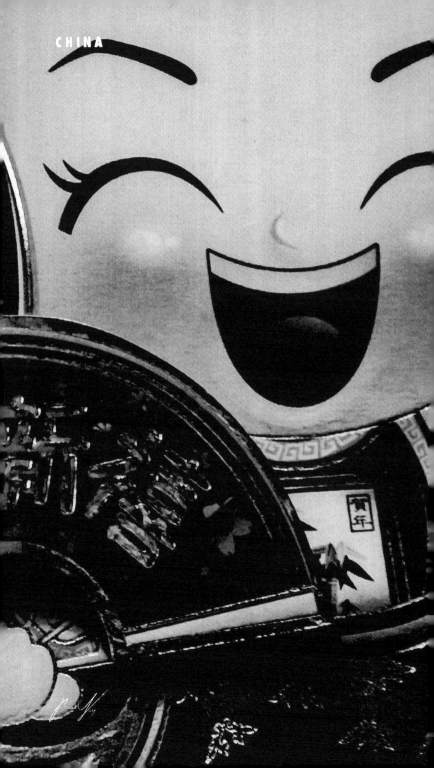

PREFACE

With great pleasure, this book of Daily Inspiration has been created. With even greater satisfaction, it is now yours to enjoy.

Have you ever made a mistake and said, "I know better?" Well, the truth is you do. The answers to all of our problems in life have always been inside of us but the noise of life often prevents us from listening to ourselves.

Within the pages of this book are reminders of the greatness already within you. It is a guide and a tool you can use to shift your perspective when you are feeling stuck.

Sometimes, all we ever need to regain our hope is to be reminded that we are not alone. Often that requires that we hear the message from someone else but without any judgement. That is the beauty of reading this book. Within the privacy of your thoughts, you can be inspired by words and images that reconnect you to yourself.

You **can** find hope in a time of hopelessness and sometimes hope is all you will need to find the strength to change your life for the better, forever.

How to make the best use of this book:
Simply flip to any page and begin.
This is your journey.
This is your **Daily Inspiration**.

Robert Young

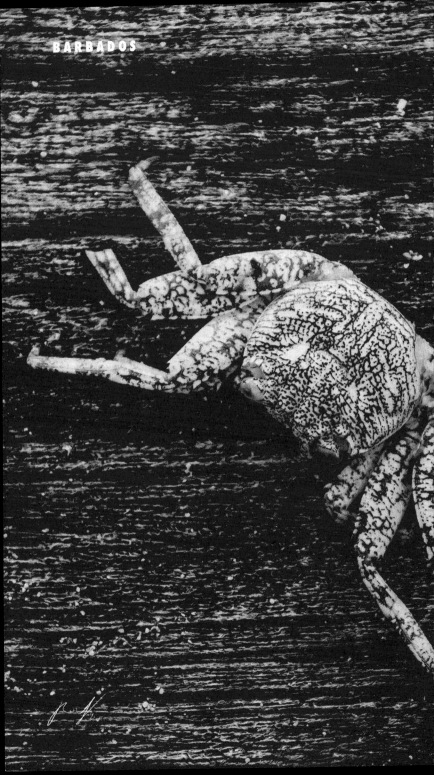

BARBADOS

Anger and judgment are costly. They consume vital energy and **create** negative vibrations that distract from our inner peace. I am not presuming that one should ignore all that a neighbour does to disturb them but instead **change** the perspective of what is identified as a disturbance.

Circumstances that do not physically harm you are not in and of themselves issues but thinking they are will certainly make them so.

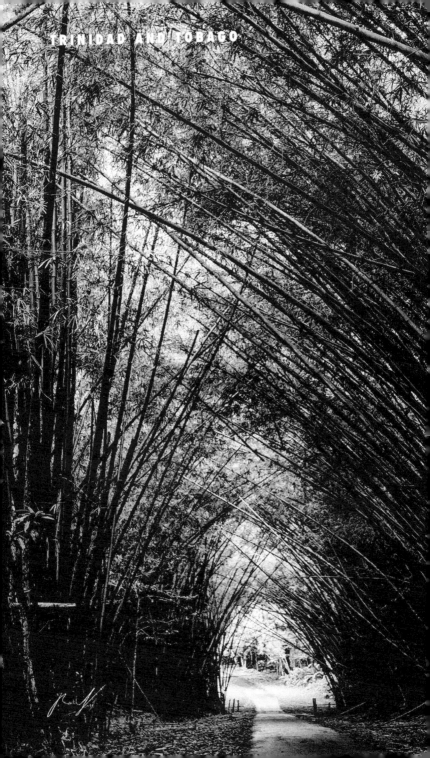

TRINIDAD AND TOBAGO

Support that you can access anywhere, at any time, is an immeasurable gift. This life will go on whether we are active participants in it or not. So I suggest taking the time to recognize there is a path put before us that can deliver both

joy and ultimately **peace**. One need only to stop, listen, and look inward, for although

humanity **is** great, we are but

sheep in the context of **the** universe. While some of us stray

away from the **path** only

to find temporary satisfaction and ongoing misery, others humbly accept our role and

follow it to a place where all that we will ever need is provided for us.

Evidence of **love** is in our existence. No matter the **circumstances**, we are all the product of love. If not for love we could not have been conceived, **birthed**, fed, and raised. Thus, the idea that we are somehow more different than we are alike is the most detrimental lie humanity has ever proliferated. This lie is a cancer, but one that is curable **by** merely revealing the **truth** in a way humankind cannot deny. The love that birthed us is the love that can heal all wounds.

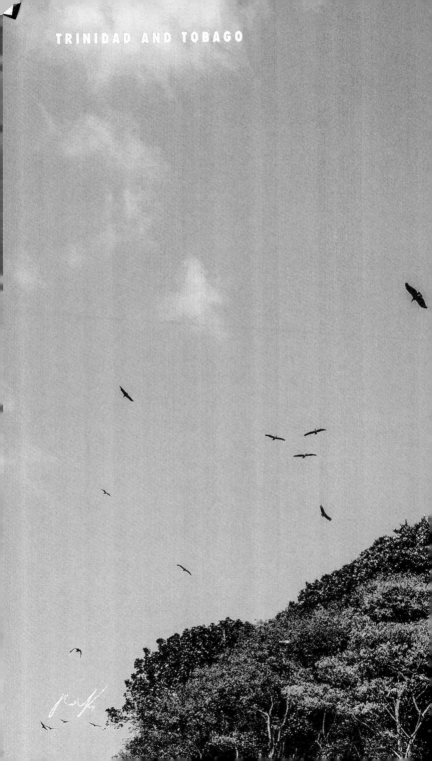

Days differ. Some are simply greater than others. Some days spirits **soar** while on others a sense of intellectual, emotional paralysis seems to want to set in. In the **high** times spread your love, embrace your joy, **and** be infectious with inspiration. Share. In the low times, though it may be difficult, do not give negative thoughts your attention, instead get up and get outside of yourself.

Seek a way to serve others as it can and will uplift you. When you are suffering, it feels like you have little energy. Give that energy away to build joy in someone else, and you will be given back that energy ten-fold.

Sharing **love** is the ultimate internal recharger.

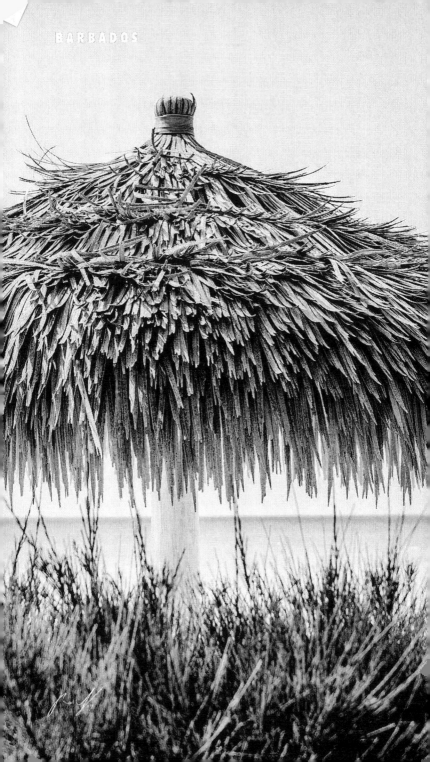

Nothing can **be** achieved without hope. We cannot leave the house to buy a loaf of bread without the hope that it will be at the store. But hope alone is not enough to fulfil our elaborate dreams. One must match their hope with action. Doing, not just hoping, is what makes our

dreams come **true**.

That which we **achieve** is never accomplished alone. Recognize your accomplishments by way of honouring the power **greater** than yourself that drove you to **success**. When you give credit **in** this way, you will find it much easier to spread the word of your accomplishments and be heard. **Humility** in your greatness pays dividends not only in your heart but in your reputation.

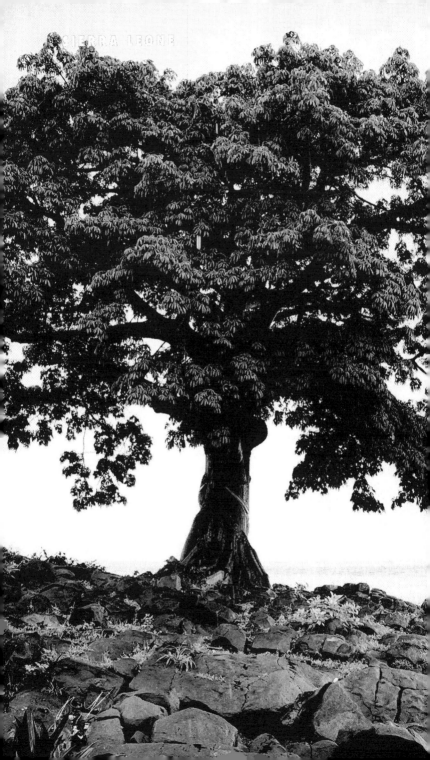

If you are going to make an effort to plant seeds with **your** dreams, thoughts, and **actions** why not plant a massive oak rather than a single flower. Though a flower may quickly garner your attention for its beauty, it **will** also soon wither away and die. An oak tree, however, may be more difficult to plant and take a great many more years of care to grow but when it does, it will not only give you something to lean on when you are tired but it will also **provide** shade for others. In your giving to the world, rather than taking from it, you will reap **fulfilment** for a lifetime.

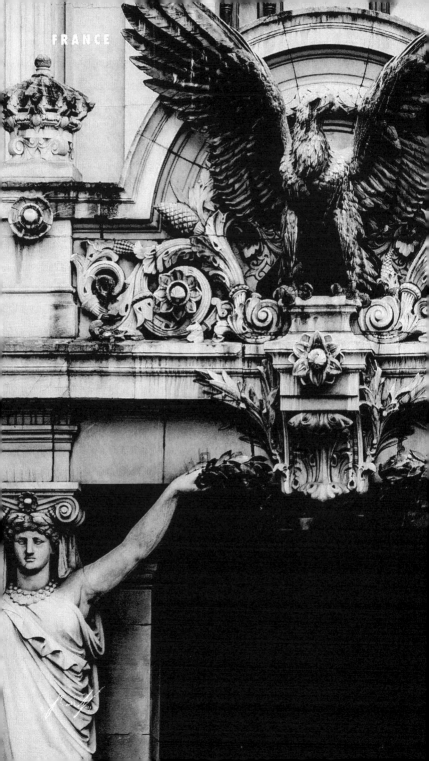

The time for triumph has arrived. No matter where these words meet you in **your** life, the moment of your **salvation** is now. Your redemption is a matter of choice.

Breathing out **is** your automatic giving unto the world while breathing **in** is your receiving what the world has to offer you. Recognize the reciprocal dimension of your life, for which **you** have no control but by which you are already whole.

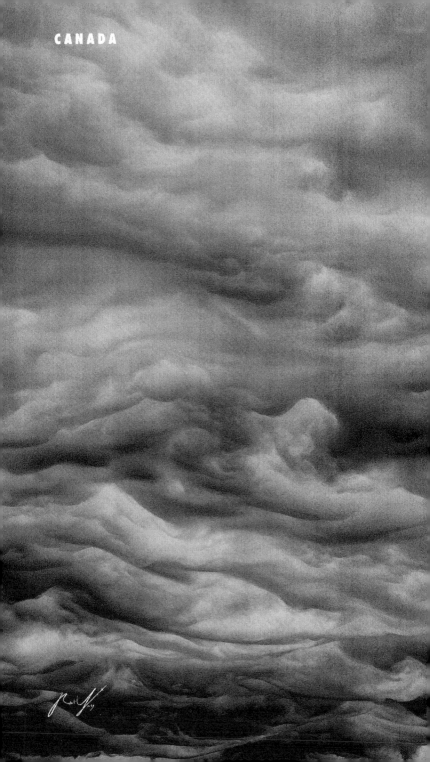

CANADA

Your mortal being, flesh, and blood, is not for the slaughter. Do not treat it as such. Your body is a temple, built upon a miraculous foundation. Do not add to it that which devalues it. Instead caretake yourself more than any

expensive object, for **you** are of the greatest value, created at great expense, and meant for a magnificent purpose. You

alone **are** the appraiser of your worth. Your body is

the **magnificent** manifestation of your spiritual being on earth. Appraise it, and yourself, accordingly.

Be alive **always**. Great sacrifices have been made in the past so that humanity could exist. Lift yourself to greater heights in

honour, not only of you but of those who came before you. The way forward has been paved for you but what use is it if you stand still. Give no credence to struggle, instead find the strength it has built up in you and let it lift your spirit in reverence and in awe of that which is

greater than **yourself**. By striving to move forward you may move beyond expectation and be delivered by the very struggle that once hindered you.

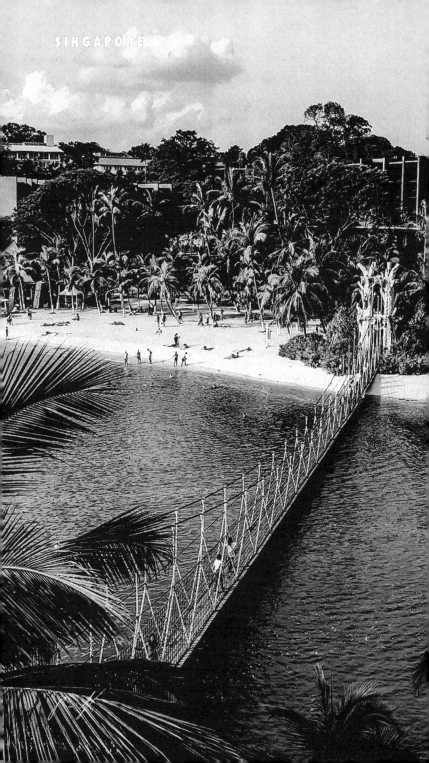

When you are at your most excellent, give thanks. **Gratitude** is the appreciation for what is. It prepares us for what can be and **fortifies** us against the dips in the road of life. Build up your spiritual currency. Make it a daily practice so that when **you** are at a loss, you can see your way out of a troubled time. Know that even when you are lost, there is still a guide working in your favour to lead you back to the path of hope. Find peace in knowing that you are never alone.

BARBADOS

Know that any hardship you **have** ever suffered has been sharpening, expanding, preparing, and disciplining you to do remarkable things. It is apparent that it doesn't feel good to reach the end of your rope, but you must hold on to the awareness that you will survive what you are going through today. You will not only survive it, but you will reap the most significant harvest from your seeds of despair if you but water

them with **patience**. You are being sewn, and you shall bear fruit, but you must wait for the ripening of your spirit. It will come.

Examples of how to live our life beyond ego are everywhere. It is up to us to open our eyes, **refocus** our attention, and simply look to the inspiration

within. Just accept **your** heart and you will see a path clear before you so you may escape the wilderness of your **mind**.

ROMANIA

Fortify yourself against any loss of confidence. **You** are a living, breathing confirmation of life. Look at yourself, look into yourself, feel your heart beating in your chest and know that you

are a miracle. You are a miracle created to create more miracles. Against all **the** odds, know that you will succeed if you stand and move forward with your beliefs intact. Set your destination, embrace your inspiration, and follow the path willingly as a river flows into the ocean. Your journey may take you places you had not expected, but the path will lead to your

greatest destination as long as you stay on it.

If you look at the heart of all failure and all triumph there is a common thread and dividing factor, **Trust**. Believe in something greater and you will eventually see the importance of trusting yourself. Often, a supportive outside perspective of our own lives can reveal the truth about our internal strengths and external blessings. A circle starts from a point and reaches outwardly until suddenly and miraculously it arrives where it began, only to find that what lies within us is all that mattered in the first place. Know thy self through the reciprocal duality of faith. Trust in **your** life journey, no matter how difficult it seems at times. Be anchored in the destination that is your whole and complete **self**.

Refresh your spirit daily with gratitude and appreciation. Extremes of life ironically yield the same results. During times of both ultimate happiness and ultimate sadness, we often forget to be thankful for the small blessings in our lives. We lose **focus** and become self-centered in the philosophy that what is happening to us is all because of us. For example, the financially successful say, "I worked hard for this" and pat themselves **on** the back, while the suffering say,

"This is all my fault" and beat themselves up. In both cases, when we lose the ability to be grateful we inherit a burden of responsibility, in arrogance or self-pity, that is detrimental to our

long-term **happiness**. Remember to check in with yourself daily **and** positively reassess and embrace the good

in your life. **Rejoice** in the small things that give you joy and be recharged to take on the new day with a sense of appreciation and optimism.

You were created for a purpose, designed to exceed. **Be** open to spiritual guidance and advisement. The world presents us with a plethora of options keeping our minds busy debating the way to success. In the end, the debate leaves us paralyzed, unable to act on anything. Take a moment and reside in the fact that there is only one path to our peace and contentment. That path requires that we get out of our heads and be driven by our hearts. Your destination will be revealed to you in the doing, the actual living of life not in the thinking about it. Your success and your joy will come by way of passionate action, divine guidance, and **definitive** focus.

SAINT VINCENT AND THE GRENADINES

Compassion is a characteristic of the strong and the bold. To love what is lovely is a simple task, however loving that which disgusts you is the accomplishment of a person of great strength. This type of love is achievable for us all. It **requires** not only humility but **perseverance**, for when you love with all your heart you risk it being broken by those who are themselves broken. So love with all your spirit for then you will be protected by your wholeness and rewarded for your greater intention. Through a great love for yourself and others, you will gain providence and wisdom to serve you for an eternity. In caring for others we uplift ourselves.

CANADA

You are God's magnificent creation, moulded like clay into perfection within your mother's womb. We cannot deny the miracle of our existence for we

all **are** walking, breathing works of art. Be who you were born to be. Create from the passion that you were created. Build, do not destroy. Love, do not hate. Be in awe but do not be afraid. Accept and know you are

whole, **miraculous**, and born a wonder to this world. It would not be the same without you.

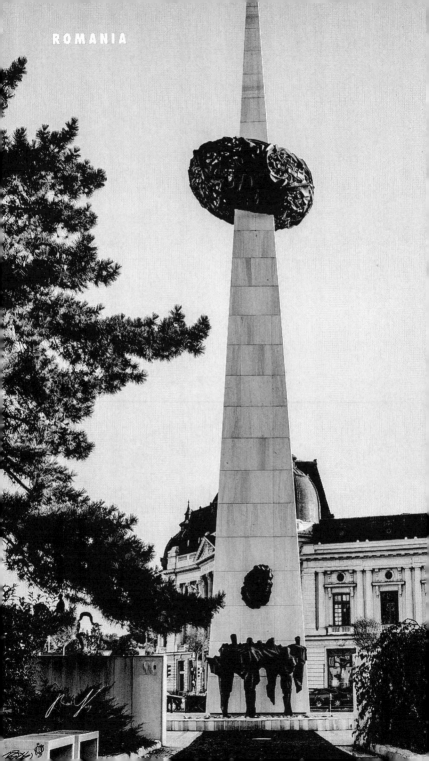

ROMANIA

Anchor yourself in **faith**. Take on the challenge to live at a higher standard, fearlessly. Be not swayed by the contention of the world but rather bathe in

its innocence. There **is** peace for those who seek it, love for those who embrace it, laughter for those who smile, success for those who work diligently, and contentment for those who seek stillness. Partake in silence and

embrace **patience**. Be rooted in your full commitment to something greater. Know that it is serving you now. Know that it will serve you always. Have faith.

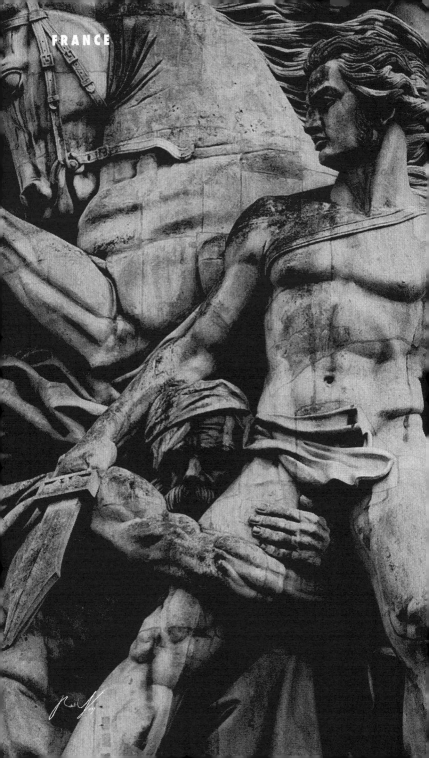

FRANCE

Be love. Above all things, simply embody love. It is **a** shield and a sword, a protector and defender, a **warrior** for humanity and the saviour of the world. Nothing else has its power, **for** true **love** subdues all opponents, even ourselves. If you are with money, fame, riches, and respect but you are without peace then you have only one primary focus; find, nurture, grow, develop, and accept, self-love. When you wholly love yourself contentment comes with ease.

BARBADOS

When we give thanks we **receive** grace. Gratitude is the gift that fulfils us when we give it. For an eternity, being thankful has produced wonder and grace in the world. Such grace is available to us always. Having gratitude for all that we are and have, the successes and the tribulation, means that we accept that our life experiences exist to make us better every day. So be grateful and know that grace will follow you forever, wherever you go.

UNITED STATES OF AMERICA

Seek knowledge and be rewarded beyond comprehension. While in the grip of ignorance, our tightly closed eyes cause us to trip over unseen objects. But through sight, you can relinquish your fear, and gather the information that will steer you clear of most obstacles and teach you how to navigate the rest. When we trust that great **knowledge** abounds and seek it earnestly, we find answers to questions we weren't even asking **and** we grow in our ability to **manifest** life at its best. Do not let failure close you off to the **wealth** of potential that you are. Rather, be open to receiving answers that are readily available to you the moment you choose to open your eyes.

COLOMBIA

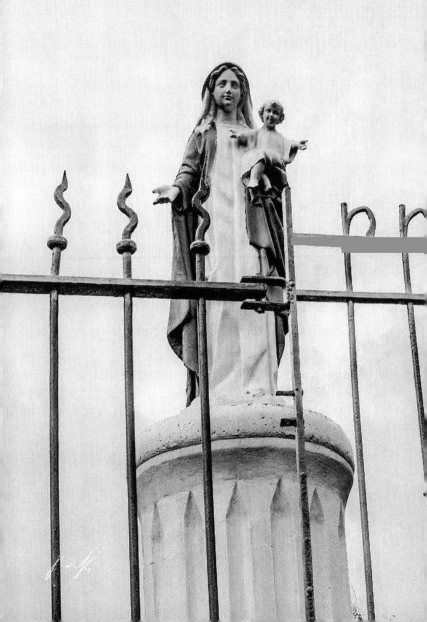

Pray not just for yourself but for the good of all people, from low places to places of

power and authority. **For** you know not what lays beneath the exterior of someone, except for this; that there within lies a heart and that because it beats can be broken. It is great to assume that

everyone is blessed. It is greater still to believe that you can be a blessing.

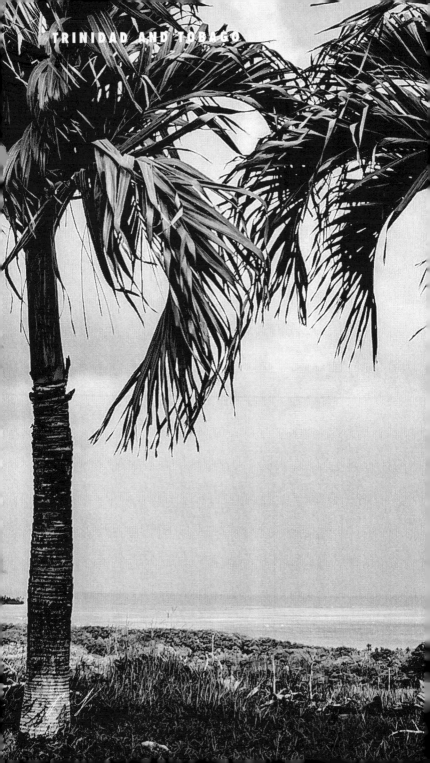

No matter how the few have tried to tell the many we are not, we are related. Let us erase hysteria and **dissolve** lies regarding our **differences** by revealing the truth about our commonalities. Today is what we have so let us begin there, **with** new thoughts and new perspectives as to **our** brotherhood and sisterhood. Set your sights on the enemy named mistrust and let us together be victorious in our **humanity**.

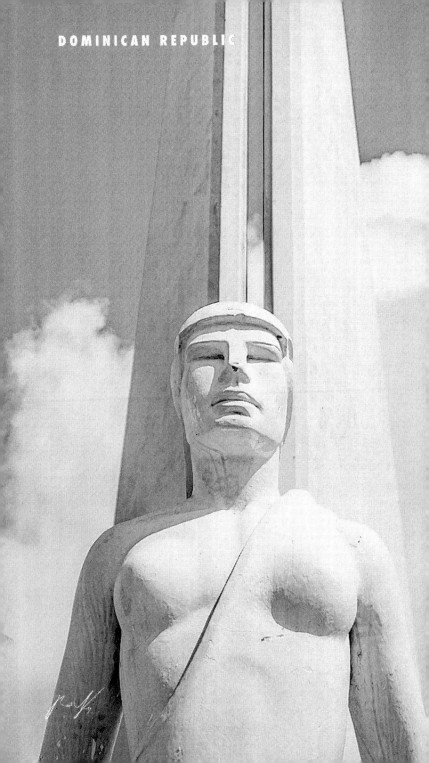

There will be a time when tribulations will pass and you will **stand** triumphantly atop a pedestal. Do not ask if but know that when it comes it will be the right and intended time for you. What is required here then is actionable patience, by which you **faithfully** continue to work at your dreams, assured that their becoming a reality is an inevitability. Assess your dreams carefully to be sure they are founded in a way of being rather than a possession. A new house will deliver temporary joy but contentment is forever.

COLOMBIA

When guided by perfection we expand ourselves to new and incredible heights. So do not be a follower of men or women who are suspect. Your salvation has already been given unto you in the form of a miraculous guide that will see you through your life's journey. Be not fooled by the shiny allure of earthly riches displayed by loud provocateurs.

Instead, **recognize** your endless wealth within and be counselled on its use for the greater good of yourself and others. Let **providence** be the shadow of your life and you will **always** walk in the sun.

What is written is eternal. What is said is remembered. What is shared shifts consciousness.

Be mindful of the messages you communicate to the world for they become your legacy. Give credence to the legend that you are and the effect you truly have. Take pause to evaluate what messages you are expressing to the world. For we are made in the likeness of that which is **great**. Thus, through our words, we should not be the creator of molehills, but of mountains.

63

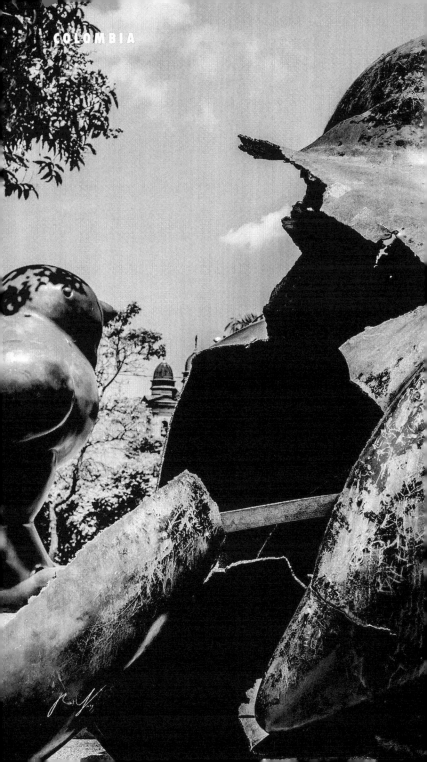

To learn from life we must first respect it. Though every breath is a miracle, on occasion, we find ourselves struggling based on self-induced bouts with the illusion of lack. When we **honour** what we have by way of recognizing our incredible lives and we are thankful for our existence, only then will we learn the truest lessons life has to teach. Set **your** mind upon the study of righteous rules of engagement and a purposeful life will be delivered unto you. When we proudly and humbly embrace our **existence**, we are destined to learn from it.

Perseverance is paramount to destiny. **Your** destiny has already been written, but like any other type of **destination**, you cannot get there if you do not try, if you do not fight through procrastination, if you do not persevere in the direction of your ultimate contentment. How beautiful a thing it **is** to go to sleep each night knowing you gave **your** heart and soul to your **destiny**. So get up, seek righteous direction, and move toward your well-deserved reward of a life fulfilled.

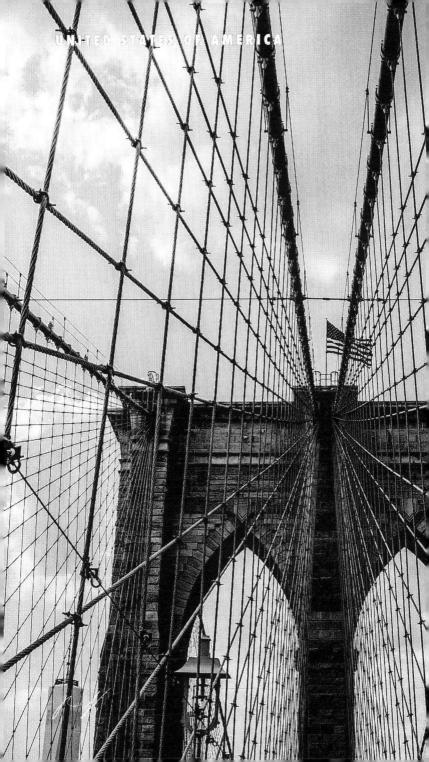
UNITED STATES OF AMERICA

You are being heard so continue to speak out. Your voice is both the asking and answering to your prayers, for in it lies the very **inspiration** that has built every city and torn down every nation. Be careful then, what you ask for. Use your power to heal yourself and others. When you ask earnestly for something it shall be given, so ask for that which does not hinder but rather **nurtures** your **growth**. Your words lay the path to your actions. Speak accordingly.

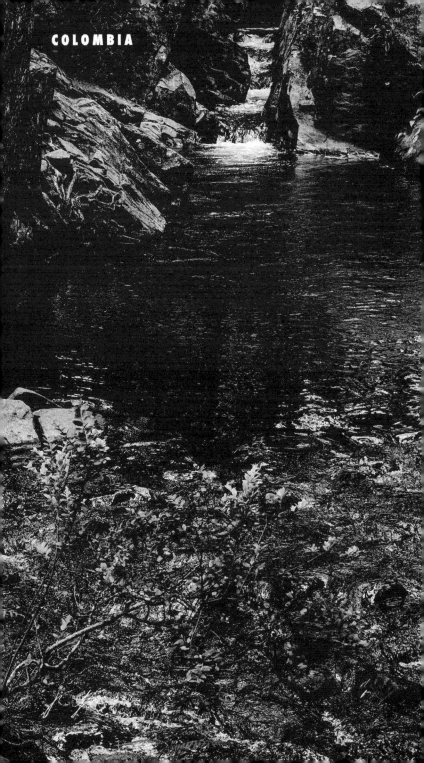

COLOMBIA

Creation is the constant immovable mountain. Lean on it, for it is both stable and eternal. Do not **trust** in that which is temporary, but rather flow willingly like the river forever faithful in its destination. When you are feeling lost, simply observe the miracles that surround you, then center yourself and look directly into the mirror. In it, you will see the most magnificent creature **creation** has ever produced. You will be forever supported if you trust eternally in creation.

Through these lips **travel** words shared in return for the sweet taste of life they have experienced. A full life behind me I continue to seek more cups to fill that I may someday simply overflow and spill **righteous** words like a waterfall gently transforming jagged rocks into smooth rolling stones. This has been my life, this is my ongoing **desire**, to share what has been so graciously given to me. May you see through life's blind spots and continue to choose to keep your head up and take refuge in that which is greater than yourself. Do this and you will see your day of righteous reckoning. Be content in your being, for your life is a gift that **expands** the world. Use it.

Focus on the destination and you **will** find every obstacle will **transform** into a helpful guide. Only when we lose focus, either through disappointment or even excitement, do we then feel an uneasiness in our lives. Amid such circumstances, we can wallow in the moment or attempt to fight through it. Neither of these tactics serve us. Stillness, however, and a simple but definitive refocusing on your greatest destination will

immediately put **you** back on the path of least resistance. Focus is the essence of visioning your dreams so that you may see them through to fruition.

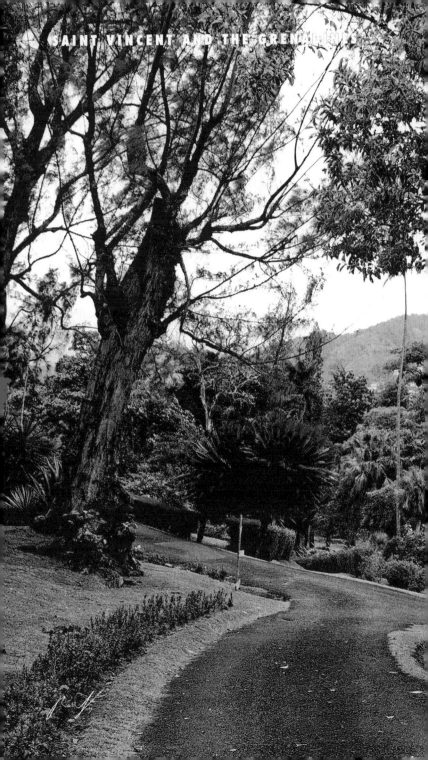
SAINT VINCENT AND THE GRENADINES

Are you alive today? By default, the fact that you are currently receiving this message means the answer is undeniable, yes. All parts of your life journey sum up your existence. If that is true of the past, then it is time to be clear about your present steps.

Acknowledge that your path is taking you to your destination even when you feel lost. In recognizing this fact you can forgive **yourself** for presumably incorrect turns you have taken. Focus on receiving righteous guidance and acknowledging your destination is grand, is beautiful, and is inevitable. If you accept and embrace that your path is taking you to a miraculous destination, you will be the light. Trust in the way.

It takes no great effort to be wicked. A tongue can lash out as easily as a dog wags its tail. Thus, the weak seek to destroy with the simplest weapon available to them, words. Do not participate in such folly. Do not wallow in such shameful behaviour. Instead, endeavour to be pure in your expression, even when those who you are speaking with or about seem not to deserve such grace. In the end, you are harmed or uplifted by your actions, so act accordingly.

No one can be two things at once. No river can be land, no wind can be rain, no fire can be metal. Neither can you be both righteous and evil simultaneously, so **choose**. Playing in such duality is madness. Seeking **contentment** through kind words develops character that will serve you all of the days of your life. Let your tongue lead you with righteous expression and your body and spirit will follow.

BARBADOS

In envy, you will **find** the seed of selfish ambition. What is yours is yours. Do not neglect the very miracle of your own life by desiring that which others have. Discard seeds of envy in your heart and selfishness in your mind, for they are destined to grow into poisoned fruit, leaving you longing and hungry. Instead, bathe in gratitude for what is already yours and

in **humility**, you will harvest abundantly and be fed for an eternity.

Your destiny is assured. Your **peace** guaranteed. But you need not be perfect to be blessed. You may fall, fail, fumble, but you are supported by a perfect journey and glorious destination. You may lose your way, but you are never lost. Your heart may break, but your spirit

is always whole. It **is** perfectly ok to be human, so give yourself a break if you've had a bad day.

Greater days are **coming**. Redemption is yours.

Anchor yourself in the truth.

Be honest with those **you** care for. If you believe they are taking a wrong turn and you say nothing, do not lie to yourself

and say you **are** preserving your friendship, when in truth you are preserving yourself. It is better to risk hurting a friend's feelings with honesty than to lead them astray with blatant lies or subversive omissions of the truth. Practice sharing honesty with gentle kindness and be an anchor for those you love, for

you and they are **worthy** of the truth.

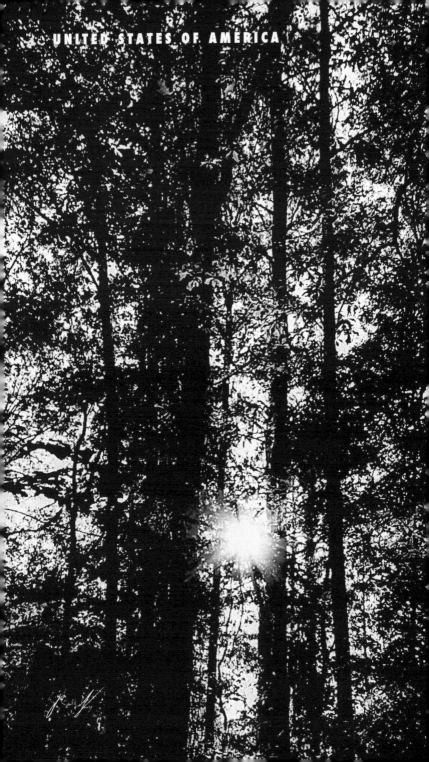
UNITED STATES OF AMERICA

Be comforted by **the** ultimate **truth** of creation, for it **is** flawless in design. We are made up of complex components with a simple and distinct purpose. Do more than endure. Live. Walk in **the** way of perfection. Be one with the **light**.

In a moment your stars can **change**. No matter how unlikely it seems, the difference between where you are and where you want to be is no more than a day away. The only issue is that you may not be ready for your blessing when it comes. Only the worthy receive contentment and only you decide if you are worthy. A force greater than you already believes you are, so what are you waiting for,

Be present in good times and bad. Do not let your mind wander into worry for tomorrow or wallow in **the** mistakes of yesterday. You have no more control over the future by thinking about it than you have the ability to change the past by remembering it. So be present. Correct what is broken now and embrace what is beautiful now, for what you do right now has the **greatest** effect on the legacy **you** leave behind and the path laid ahead. You are the present, both the **now** and the gift.

One need not search far and wide for salvation. The guide is within. It is there now, has always been, and will always be. None are without it. Few truly **submit** to it. But if you are willing to hear that still voice and listen **to** what it commands, you will find stability unlike that you have ever known. The question is how do you hear it? You must first turn off all the excess noise of life that fills your head like rush hour traffic on a morning commute. Only when you seek **serenity** will you hear the soft rustle of the wind through the leaves and the sweet sound of a songbird's melody. One voice, the voice of creation alone, holds the gift of your salvation.

BARBADOS

Love the faithless. Befriend the faithful.

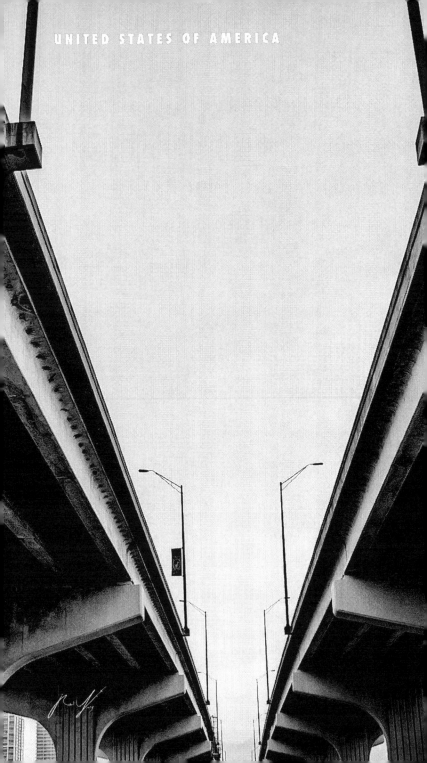

Set your eyes clearly upon your ultimate destination. But be **clear**. You cannot arrive without **a** true commitment to following the **path**. To be on track in your life is not about knowing where you are along the path, but ensuring you stay on it.

Do not fold when difficulties come into **your** life. Do not waiver when the cards seem down for that is when you should trumpet even louder, the very gift of your life. That is when you should search even harder for the beauty that is both inside of you and surrounding you.

Feeling sick; exclaim the **magnificence** of the oxygen you are breathing. Having pain; speak of the miracle of your strength to endure it. Facing financial trouble;

tell the world how wonderful it is for you to be humbled by tribulation so that when the reward of financial freedom comes you will be generous and grateful.

For every bout with the negative, there is a constant, persistent, and positive outcome that is waiting for you. Simply seek it, claim it, and exclaim it and you **will** find that the positivity you emit outwardly will not only uplift others but it will also **resonate** inwardly and change yourself.

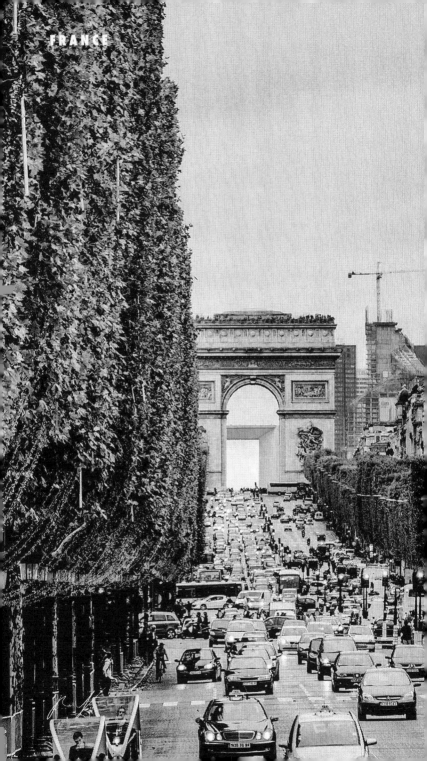

FRANCE

You must **vigorously** believe in the way until your **journey** flows as effortlessly as the river. There are forces in life that intend to build up your doubt and envelop you in grief. They do not play fair nor gently. They roughhouse you, attempting to beat you into submission. But often you submit to them after making minimal efforts to eradicate them from your life. No half-hearted prayer or simple plea for help will remove the monkey from your back. You must stand up and move fluidly past your obstacles each and every day, for it is your constant **forward** movement that will turn jagged rocks into smooth pebbles. Just as the persistent flow of water carves valleys out of mountains, you too must flow.

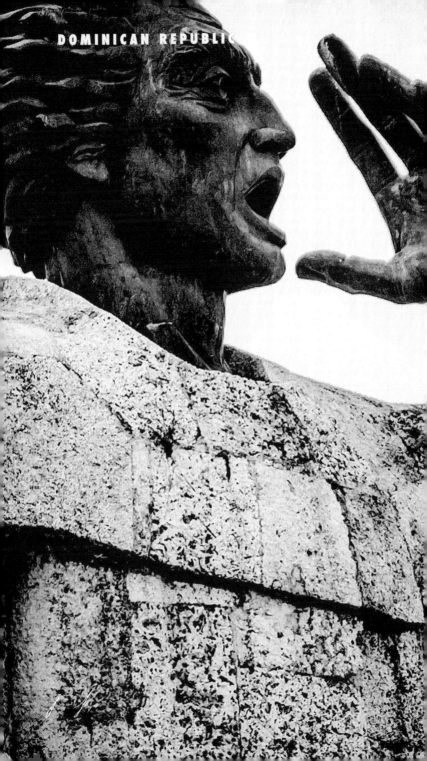

Always **speak** to creation.

Do not give **up** on the most intimate communication, for you will be heard.

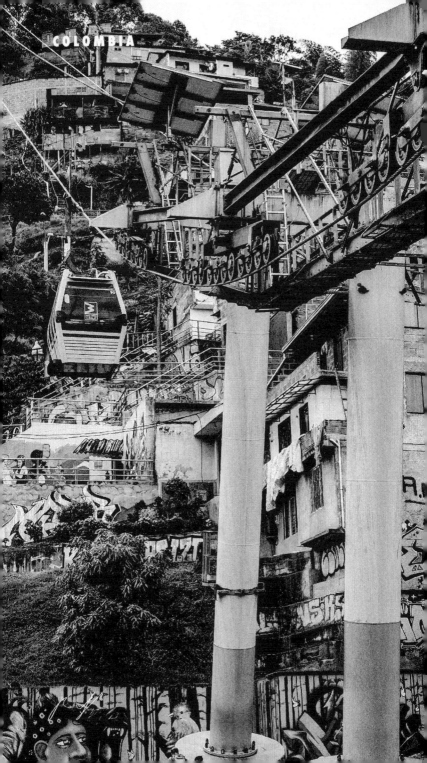

You are not the first to suffer tribulation, nor **will** you be the last to overcome it. You will **succeed**.

BARBADOS

There is no better way to **see** where you are going than to open your eyes.

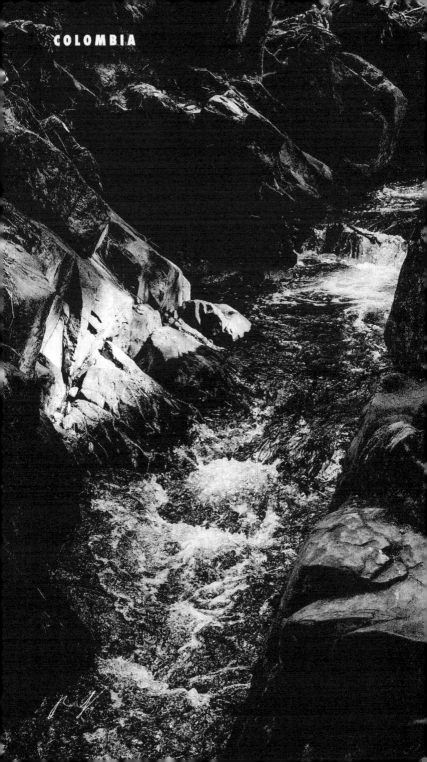
COLOMBIA

Your salvation is not guaranteed by **your** actions on earth alone but by your faith in creation.

Expect no **reward** for kindness because it **is** your nature as a human being to be kind. Wickedness and deceit take you outside of yourself and ultimately lead to destruction. So be kind, but also be faithful, for in faith you can expect reciprocity by way of **everlasting** grace and **contentment**.

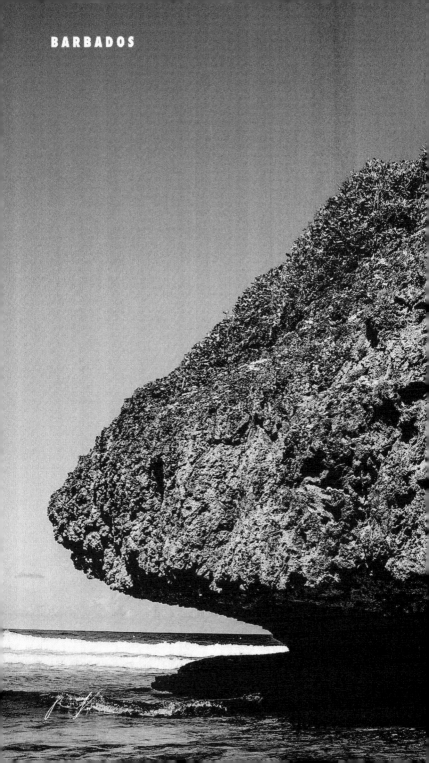

BARBADOS

Recognize that **you** are chosen. You have solid ground below you and **are** sheltered by a magnificent sky. Together they provide for your well being.

In all the glory of what **the** earth and heavens produce, isn't it blissfully ironic that it all exists for you? You are the connection. You are the common thread. You are the **median**. Rejoice,

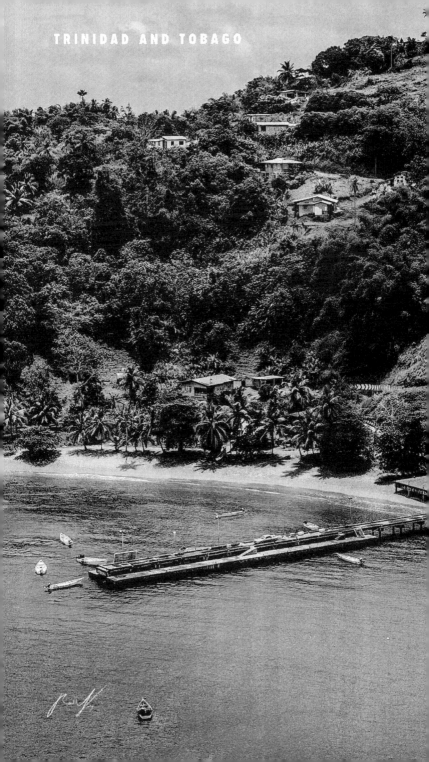

I am, is all that you need. It is the illumination of both your **inspiration** and your path. You need not search, for it **surrounds** you, it fills you, it encompasses **you**. I am the faithful. I am the transformation. I am the reflection of the sun itself. Embrace the I am, that is born of creation and eternally guides.

Commit yourself wholly **to** the path and it will take you beyond **your** wildest **dreams**.

Set thine eyes surely upon the destination and feet squarely upon the path. **Allow** yourself to be driven. Move diligently toward the attainment

of your **peace**. Do not be held back and imprisoned by your circumstances but rather, be freed by the omnipotence of your ultimate destination.

Fearlessly **exclaim** your faith. Express **gratitude** for your foundation through the art of creation. Share your treasures with the world.

UNITED STATES OF AMERICA

Create to please creation. Be wary of taking actions that are attempting to seek out **the** acceptance of man. Be mindful of your steps to ensure that they exemplify

your **greatest** good and serve your highest source. Feeding the ego is a futile endeavour, for its appetite is never satisfied. However, if you feed the spirit, hunger will be

eradicated from your **life** forever.

COLOMBIA

It is time to **sacrifice**. Sacrifice vanity. Sacrifice ego. Sacrifice fear. Sacrifice pain. Sacrifice hatred. Sacrifice ignorance. Sacrifice illusion. Sacrifice deceit. Sacrifice suffering. And save yourself.

Tune into life and adjust accordingly. When we depart from our destined path, the one that will lead us to our contentment, forces of life will **impart** auto-correction. Be mindful of mistaking stubbornness for perseverance when the correction comes. Some obstacles exist to redirect you back in the direction of your **peaceful** destiny while others exist to test your **resolve**.

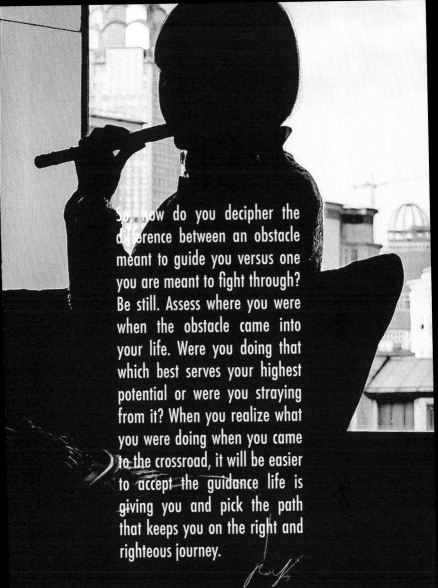

So, how do you decipher the difference between an obstacle meant to guide you versus one you are meant to fight through? Be still. Assess where you were when the obstacle came into your life. Were you doing that which best serves your highest potential or were you straying from it? When you realize what you were doing when you came to the crossroad, it will be easier to accept the guidance life is giving you and pick the path that keeps you on the right and righteous journey.

SAINT VINCENT AND THE GRENADINES

Unburden yourself. Make amends. Move forward. All that **you** seek will come to light when you **choose** to stop stumbling in the dark.

127

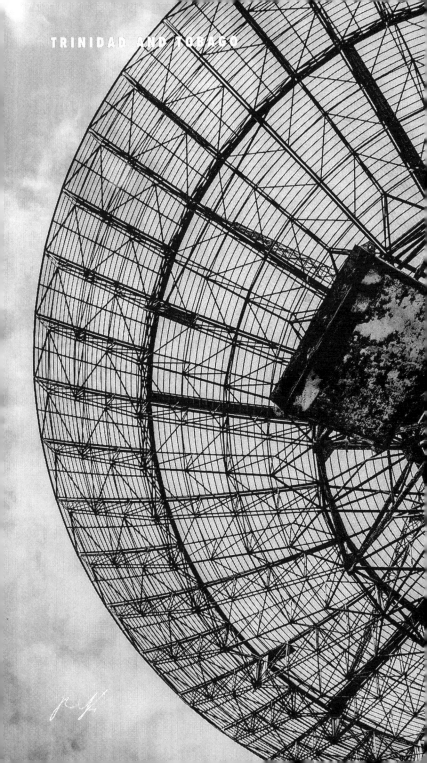

A change for the better is but a **shift** of **perspecive** away. Accept life's difficulties as discipline, for when you do so, good things are the result.

With this new paradigm of thought suddenly every challenge becomes simply a building block towards your strength, your **passion**, your courage, and most of all your character.

129

COLOMBIA

It takes humility to **grow**, for the seeds of connectedness are sewn by way of it. When we are humble, a clairvoyant understanding of global oneness arrives. Thus, seek not to simply serve yourself, but in humility, take careful consideration of the needs, interests, and desires of others, and you will

exponentially grow.

Silence the critics and inform the ignorant by being a **source** of good in **the** world. No one, not even those that are evil, can resist the seductive nature of the warm sun shining upon their face. Be the **light**.

SAINT VINCENT AND THE GRENADINES

Determine **your** destiny through mastery of your **perspective**. Faithfully embrace the sight unseen. A life filled with disruptive views of destruction **is** not a life that was intended for you. So close thine eyes and see, for within exists **the** vision that will carry you to your greatest glory. The **seed** was planted before your birth. You were not meant to just wither away and die in the eye **of** the storm but rather, you were created that you may flourish and joyfully grow through **your** determination of faith and constitution of **character**.

135

COLOMBIA

Everything you know is but a fraction of the knowledge available to you. **Gather** it like ripe fruit and fill **your** basket with all that has been given freely by creation. The **truth** amongst the rich and the poor, the old and the young, women and men alike, is this; no matter what you think you know, there is so much more you do not. Free yourself from ignorance just a little bit each day by diligently seeking knowledge. Let your spirit be lifted in discovering the omnipotence that lives within.

The **ultimate** goal is not the resistance of temptation, but

rather, **absolution** from it.

Mastery of your destiny **requires** a deep and faithful **knowing**. There are plans for your life that have existed long before your conception. Surrender **yourself** to your future prosperity by simply believing, right here and right now, that you are chosen.

COLOMBIA

You have **now**. What was, **is** like **your** last breath. What is to be, is like a breath not yet taken. Neither are within your control. This very **moment**, however, is yours. Own it.

There is great power within you. At times it can be **buried** so deep under despair that you can forget it exists. But rest assured, **underneath** the layers of **doubt** and questions are answers and strength that await your acknowledgement. The recognition of the truth of your own internal power **is** a vital tool in the attainment of personal **peace**.

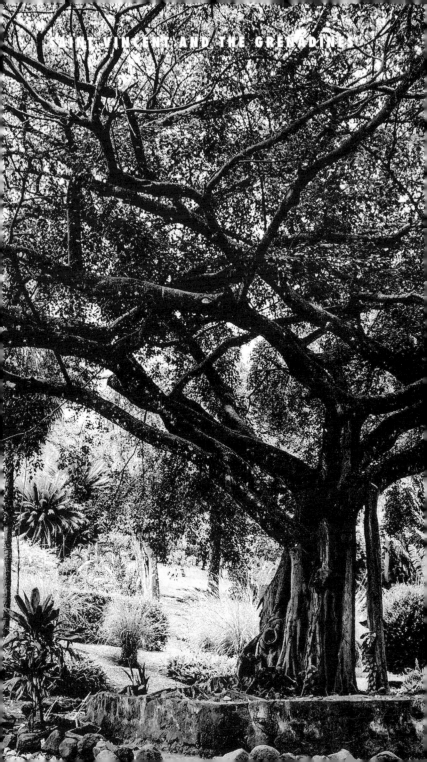

Through **love**, be fulfilled. Seek out every single positive point in your **life** and embrace it, for that which you focus upon grows. This works for both good and evil, thus it is important that you disregard distress and fully engage all the reasons to love yourself. With love, you can triumph over any tribulation.

UNITED STATES OF AMERICA

LIVE,

WOR

CREA

Make a **promise** to **yourself** and keep it. Cement the foundation of your character through accountability.

Design **a** promise that betters your life and read it daily. Repeat it unto yourself as often as you like, and especially when you cross paths with difficulty. Do this until it becomes second nature. Like a **great** boxer who knows when to throw a counterpunch without thinking about it or a race car driver who gears down as he enters a sharp curve with little to no contemplation, as you make it your practice to resort to your personal promise daily, you too will eventually act instinctually in ways that best serve you when trials show up in your **life**. What a gift it will be to face tribulation without panic and instead, just gracefully, be.

CANADA

Partake in what you love and it will **serve** you now and forever.

Keep magnificent company. Do not walk with those who stumble, for eventually you will get tripped up and fall. Instead, surround yourself with **champions** and the champion in you will surface. Iron sharpens iron, just as diamonds cut diamonds. **Choose** your company accordingly.

DOMINICAN REPUBLIC

Build your kingdom with action. Surrender not to laziness and inactivity. **Surrender** to faith. Believe in the fact that when you try, you will succeed. One step must be taken for a second step to be an option. Get up, get going, get active.

COLOMBIA

Be a tree **well-rooted** in fertile soil, so that when the wind of negative influence starts to blow, those who look up to you can take hold of the powerful branches of knowledge you possess. The world can be a surreal place for the young. Its many stimulants influence the mind in a multitude of ways. Unchecked, such influence can railroad a once-promising future. Do not let the young be wholly taken from their innocence. Live by a righteous code and you can be a mirror reflecting light upon the lost.

Give gratitude for your remarkable gift of life. Give **thanks** not just in words and thought but in action. Make a life worthy of gratitude. Rise from despair. Move on from disappointment. Graduate from the high school of the world and become a freshman at the University of the Spirit. Study your self and embrace the gift you have been chosen to receive; life.

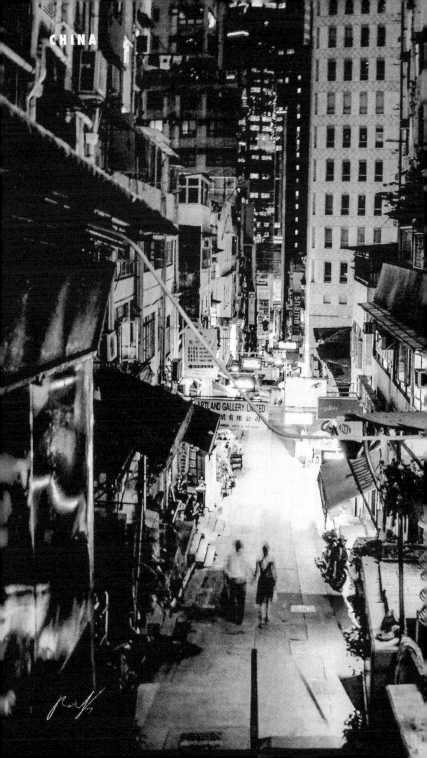

Make love to **life**. Care for it and demand from it the joy and contentment you deserve. Give to it as passionately, as you wish it to give to you in return. Engage life knowing it is **yours** to keep, yours **to** embrace, yours to **master**.

Use these pages daily as a blank canvas to
stoke the fires of inspiration and hope growing within you.
Once you've filled these pages continue to write in a journal.

Remember, the answers to all of life's problems
are already inside you.
Express and **See Yourself**.

Curating Life Through The Language Of Design

ROBERT YOUNG

Robert Young is a modern-day renaissance man. As an author, auteur, artisan, designer and orator, his aptitude for storytelling is exemplified through 3 decades of work in the creative industries.

Young has an undying passion to seek out and share worldly experiences through the creation of tangible and powerful expressions that connect on an emotional level and celebrate human triumph.

In 2014, driven by unexplainable desire, Young awoke before sunrise for 70 days to write the parables that would become this book. Little did he know, that only a few months later, these very words would become his lifeline when his mother passed away unexpectedly in her sleep. These once private writings are now yours to read, yours to use and yours to share.

"Creativity is a beacon for hope. Where there is hope there is healing and where-in you are healed, so to Am I."

ROBERT**YOUNG**IAM.com